# Moira Huntly

# Draw in Brush & Ink

Series editors:
David and Brenda Herbert

A & C Black · London

First published 1981
New style of paperback binding 1995
Reprint 1998
by A & C Black (Publishers) Limited
35 Bedford Row, London WC1R 4JH

ISBN 0-7136-4237-8

Printed in Hong Kong by Wing King Tong

# Contents

# Making a start

Most people find it natural to scribble, but believe they are unable to draw. But if you really want to draw and are prepared to work hard, you may be surprised at how much you can achieve. To be able to sketch what you see can be very rewarding, and ink is an exciting and versatile medium.

Drawing in ink may seem frightening because you know that it cannot easily be erased. Talk yourself out of this fear—all drawing is exploratory, and mistakes are part of the learning process and can often be absorbed into the drawing. Keep a sketchbook handy and make plenty of quick, free notes—only by constantly using ink will you gain confidence. Don't be shy of using your sketchbook in public, either for quick sketches to be used later, or for a finished drawing.

Learning to draw is largely a matter of practice and observation—so draw as much and as often as you can, and use your eyes all the time.

The time you spend on a drawing is not important. A ten-minute sketch can say more than a slow, painstaking drawing that takes many hours.

To do an interesting drawing, you must enjoy it. Even if you start on something that doesn't particularly interest you, you will probably find that the act of drawing it—and looking at it in a new way—creates its own excitement. The less you think about how you are drawing and the more you think about what you are drawing, the better your drawing will be.

The best equipment will not itself make you a better artist—but good equipment is encouraging and pleasant to use, so buy the best you can afford and don't be afraid to use it freely.

Be as bold as you dare. It's your piece of paper and you can do what you like with it. Be self-critical. If a drawing looks wrong, scrap it and start again. A second, third or even fourth attempt will often be better than the first, because you are learning about the subject all the time.

You can learn a certain amount from copying other people's drawings. But you will learn more from a drawing done from direct observation of the subject or even out of your head, however stiff and unsatisfactory the results may seem at first.

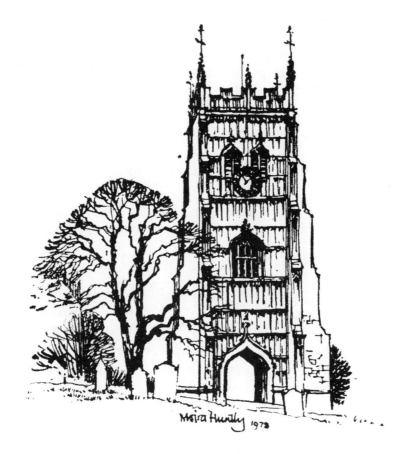

# What to draw with

Ultra fine Fibre Tip

Medium Felt Pen

Medium
Felt Pen

Ultra Fine
Fibre Pen

303
Drawing
Nib

**Pens** vary widely, and it is worth experimenting with different kinds to find out what they will do and which you prefer.

Mapping pens are only suitable for delicate detail and minute cross-hatching.

Special artists' pens, such as Gillott 303 or Gillott 404, allow you a more varied line, according to the angle at which you hold them and the pressure you use. The Gillott 659 is a very popular crowquill pen.

Reed, bamboo and quill pens are good for bold lines. You can make the nib end narrower or wider with the help of a sharp knife or razor blade. This kind of pen has to be dipped frequently into the ink.

**Fountain pens** have a softer touch than dip-in pens, and many artists prefer them. Most fountain pens will only work with non-waterproof inks.

Special fountain pens, such as Rapidograph and Rotring, control the flow of ink by means of a needle valve in a fine tube (the nib). Nibs are available in several grades of fineness and are interchangeable. The line they produce is of even thickness, but on coarse paper you can draw an interesting broken line similar to that of a crayon. These pens have to be held at a right-angle to the paper, which is a disadvantage.

**Ball point pens** make a drawing look a bit mechanical, but they are cheap and fool-proof and useful for quick notes and scribbles.

**Fibre pens** are only slightly better, and their points tend to wear down quickly.

**Felt-tip pens** are useful for quick notes and sketches but are not good for more elaborate and finished drawings.

**Brushes** are very versatile drawing instruments. The Chinese and Japanese know this and until recently never used anything else, even for writing.

The best brushes are made from sable. Even the biggest sable brush will come to a fine point, and the smallest brush laid on its side produces a line broader than the broadest nib. Less

No. 1   No. 6   ⁵⁄₁₆"   Piece of Twig

WATERPROOF DRA
BLACK INDIA

expensive brushes are made from ringcat, ox-hair or squirrel and these also have good points if looked after properly.

DON'T leave a brush standing in ink or water for any length of time.

DO make sure that you wash the brush thoroughly in clean water immediately after use, dry it gently with a rag and pull it carefully into shape again between your fingers. A good sable brush can be ruined if you allow the ink to dry on it.

I use a selection of round brushes ranging in size from 0–12, and one or two flat, square-ended brushes which can give thin or thick strokes. To start with, choose one small, one medium and one large round brush and one flat brush. An old hog-hair brush can be useful for dry brush textures.

**Inks** also vary. Waterproof Indian ink quickly clogs a pen. Pelikan Fount India, which is nearly as black, flows more smoothly and does not leave a varnishy deposit on the pen. Ordinary fountain-pen or writing inks are less opaque and give a drawing more variety of tone.

There are inks made specially for drawing, and obtainable in a range of colours. Some are waterproof, others not. Only black and white inks are guaranteed permanent; coloured inks may fade in time.

You can mix water with any ink in order to make it thinner and paler—but for Indian ink use distilled or rain water, because ordinary water will make it curdle.

A stick dipped in ink can also be used to draw with and will give a variety of line depending on its thickness and whether the point is sharp or blunt.

The screw tops of some ink bottles have a quill ink dipper which can be used to make ink marks.

**Mixed methods** are often pleasing. Try making drawings with pen and wash, ink and wax (see page 46), or with a pen or brush on wet paper. Interesting marks can be made by gently pressing an inked finger onto the paper; this can be used to create textured effects.

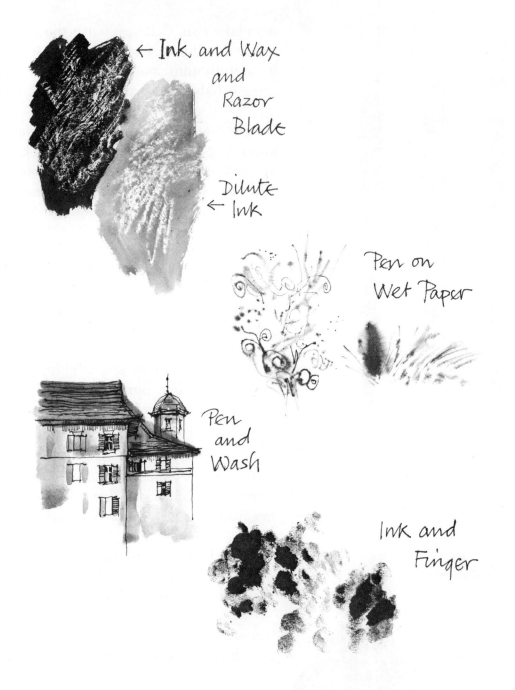

← Ink and Wax
and
Razor
Blade

Dilute
← Ink

Pen on
Wet Paper

Pen
and
Wash

Ink and
Finger

# What to draw on

Ordinary inexpensive paper can often be used for sketching: writing and duplicating papers are probably best for pen drawings. But there are many papers and brands made specially for the artist.

**Bristol board** is a smooth, hard white board designed for fine pen work.

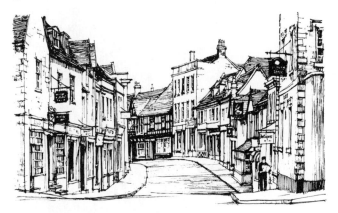

Pen and ink on Bristol board

**Ledger Bond** paper (cartridge in the UK), the most usual drawing paper, is available in a variety of surfaces—smooth, 'not surface' (semi-rough), rough—for both pen and brush work.

Brush and ink on cartridge paper

**Watercolour papers** also come in various grades of smoothness. The thicker, high-quality papers are expensive, but pleasant to use. Thin watercolour paper will buckle if it becomes very wet, making it difficult to work on. This can be prevented if the paper is thoroughly soaked in cold water before use. After soaking, lay it flat on a board and stick the edges down with brown paper tape (not self-adhesive tape). Allow an hour or so for the paper to dry flat.

**Ingres paper** has a soft, furry surface and is made in many light colours—grey, pink, blue, buff, etc. It will accept ink applied with a brush or a pen. A slightly broken line can be obtained on the more textured type of Ingres paper.

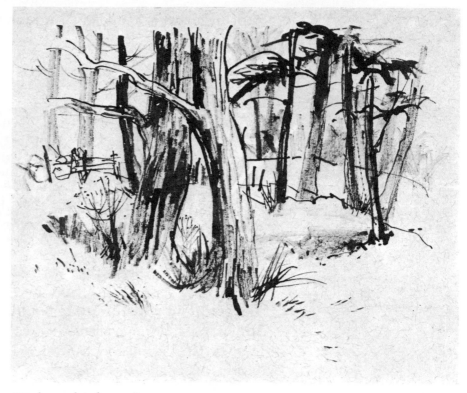

Stick and ink on Ingres paper

**Sketchbooks**, made up from nearly all these papers, are available. Choose one with thin, smooth paper to begin with. Thin paper means more pages, and a smooth surface is best to record detail.

**Lay-out pads** make useful sketchbooks. Although their covers are not stiff, you can easily insert a stiff piece of card to act as firm backing to your drawing. The paper is semi-transparent, but this can be useful—almost as tracing paper—if you want to make a new, improved version of your last drawing.

An improvised sketchbook can be just as good as a bought one—or better. Find two pieces of thick card, sandwich a stack of paper, preferably of different kinds, between them and clip them together at either end.

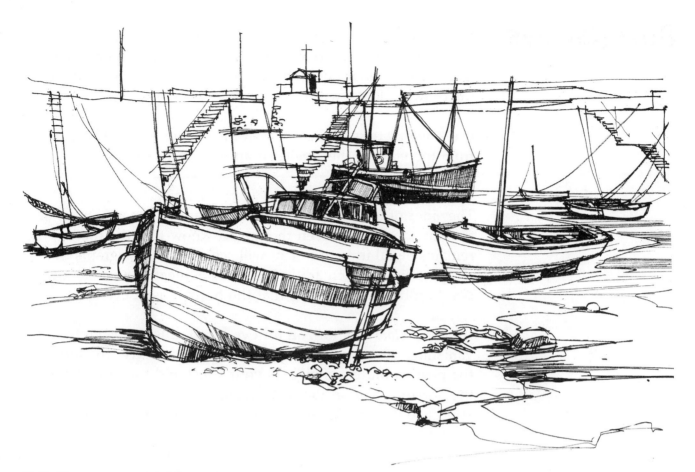

Felt-tip pen on cartridge paper

# Perspective

Perspective in drawing introduces the third dimension—it gives depth and life to an object drawn on flat paper. If you ignore the laws of perspective you will know immediately that the drawing looks wrong.

It is obvious to most people that the farther away an object is from the viewer, the smaller it appears in relation to closer objects.

The sides of a road going into the distance appear to meet at the horizon (fig. 1), even though we know that the road remains equal in width. You will see from the diagrams that receding lines which are in fact parallel meet at a vanishing point on the horizon, and that the horizon is at eye level.

All lines *below* the horizon (or eye level) must slope *up* to the vanishing point (fig. 2). If you stood by the fence, the top of the post would be as high as your waist and therefore below the horizon. Notice, too, that the spaces between the posts appear to get smaller as they disappear into the distance.

All lines *above* the horizon (or eye level) must slope *down* to the vanishing point (fig. 3). The lamp posts are much taller than you are, so the top of the nearest one must be drawn well above the horizon.

Remember constantly that objects, trees, figures, become smaller as they recede into the distance (fig. 4). Adult figures standing on level ground, whether near or distant, have the same eye level, so all the heads are drawn touching the horizon. The child is smaller so the head is drawn relatively lower.

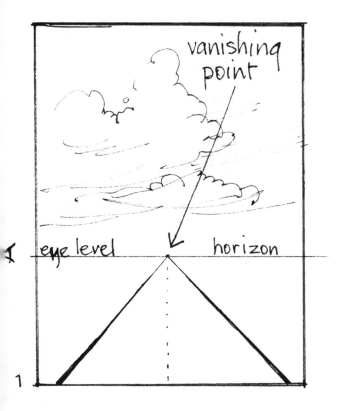

vanishing point

eye level                    horizon

1

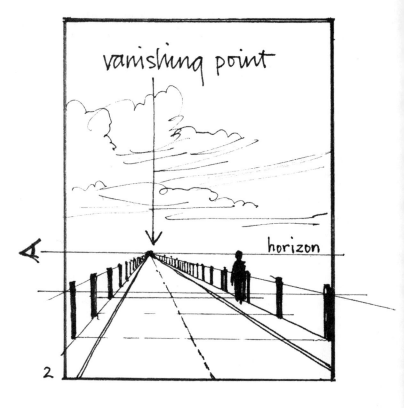

vanishing point

horizon

2

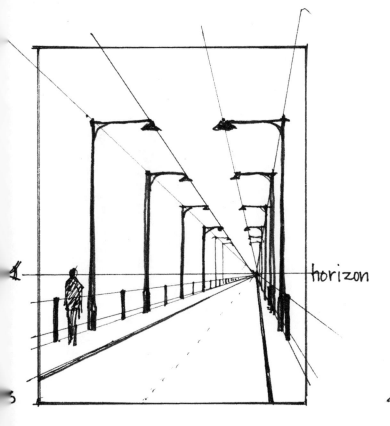

horizon

3

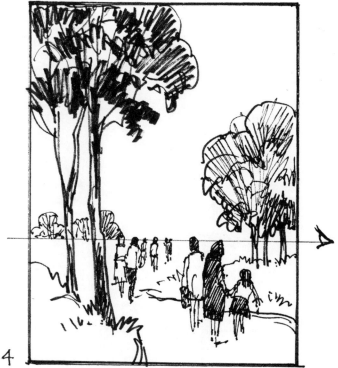

4

## Applying perspective to buildings

Basically, buildings are like boxes with differently shaped lids. To simplify this idea still further I have used a square and a triangle in my diagrams. You will see that, when viewed from an angle, the centre of the square no longer appears to be central. Remembering that things diminish in size as they go into the distance, you will notice that the further half (A) of the square is now narrower than the nearer half (B). The same applies to the triangle.

The drawings of houses below show how to apply these rules, and also how the horizontal lines of the front and sides of the houses slope towards eye level, away from the corner nearest the viewer. A straight-on front or side view is easier to tackle.

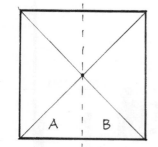

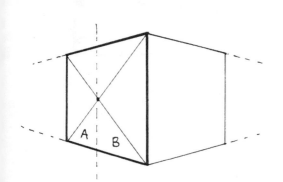

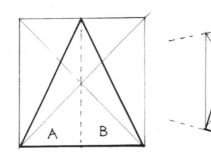

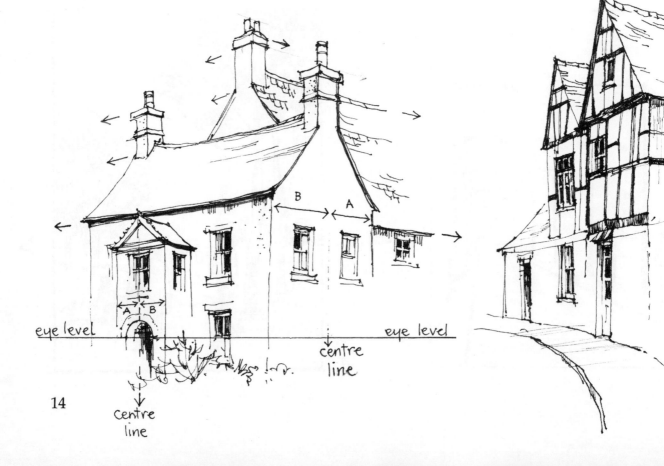

eye level

eye level

centre line

centre line

14

Start a complicated building with a light pencil outline and position the main features. Detail can be added directly with the pen later. Allow the ink to dry and set thoroughly before you attempt to rub out any pencil lines.

These drawings were made with a 303 pen nib and Indian ink.

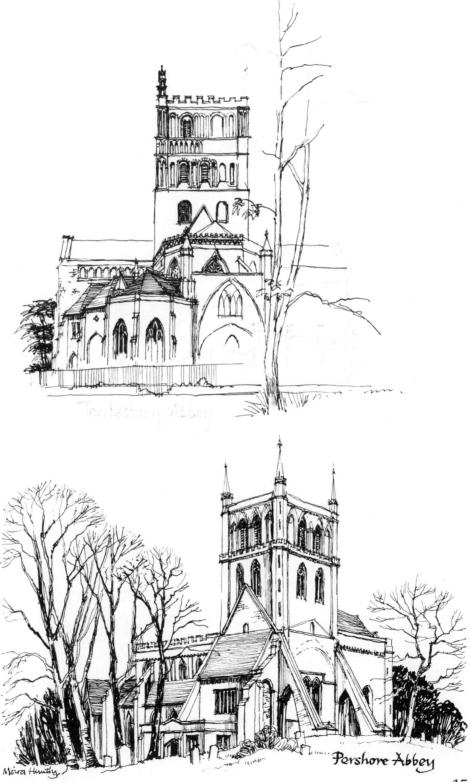

Moira Huntly

Pershore Abbey

# Composition

Unbalanced

Composition is mainly a question of deciding how to divide up a surface so as to give the greatest visual satisfaction.

Try to achieve a balance by careful arrangement of the parts. Many natural forms already possess qualities of perfect proportion, rhythm or exciting design—hence their continual study by artists.

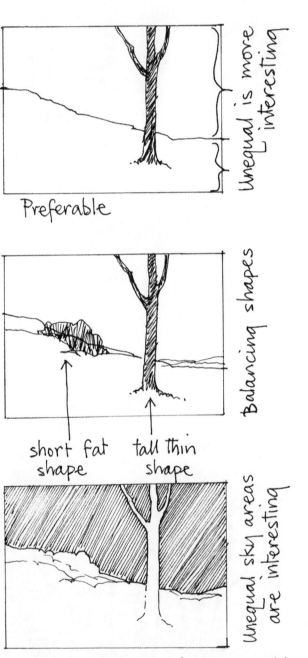

Preferable

short fat shape    tall thin shape

Looking at shapes between objects

16

Make small 'roughs' of ideas in your sketchbook to help you work out the balance of shapes and tones, trying out different arrangements of the same subject as I have done with the bridge and trees above.

Sketches with colour notes can form the basis for later paintings. In the back-yard sketch below I have made a note of different textures, as well as looking for an interesting arrangement of shapes.

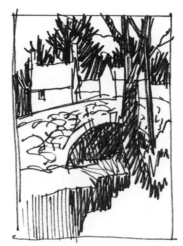
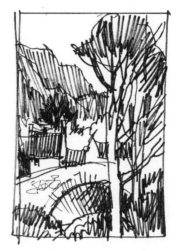

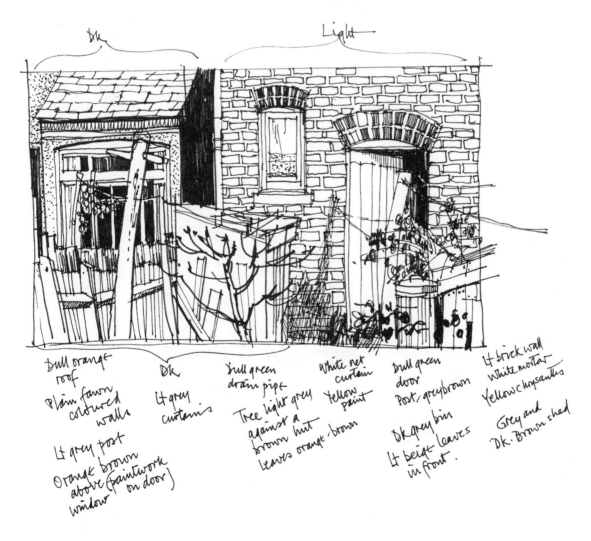

Dull orange roof
Plain fawn coloured walls
Lt grey post
Orange brown above (paintwork on door)
window

Dk
Lt grey curtains

Dull green drain pipe
Tree light grey against a brown hut
leaves orange-brown

White net curtain
Yellow paint

Dull green door
Post, greybrown
Dk grey bin
Lt beige leaves in front.

Lt brick wall
white mortar
Yellow chrysanths
Grey and Dk. Brown shed

# Drawing with brush and ink

### Holding the brush

The traditional use of brush and ink in China and Japan took a lifetime to perfect, in spite of its apparently spontaneous fluency; and masterpieces of oriental brush-work combined spiritual dedication with technical expertise. After generations of using brush and ink as a medium of communication Eastern people have an instinctive feeling for writing and drawing with a brush.

Although this kind of inherent ability may be impossible without years of intensive study, a considerable degree of skill can nevertheless be achieved through practice and an understanding of how a brush can best be used as a drawing instrument. You may be pleasantly surprised to discover what the brush in your hand will do and the variety of marks it can make.

Practise holding the brush in different positions, sometimes vertical to the paper for fine lines made with the point, and sometimes almost horizontal to make use of the whole length of the brush for broad strokes.

You will find it easier to draw both straight lines and straight wavy lines with the brush held in an upright position, with the little finger resting on the paper to steady your hand as the lines are drawn. No rulers!

BLACK INDIAN
Waterproof Drawing
Ink

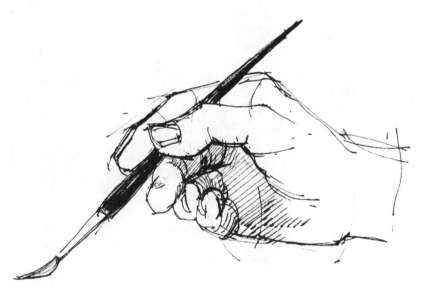

Try out the brush on a smooth paper that is not too thin. Make a few dots and dashes to get the feel of the brush on the paper. Then try the exercises on the following page. They may seem difficult to begin with, but with practice they will help you to gain control of the brush.

DON'T FORGET TO WASH THE INK OUT OF YOUR BRUSHES IMMEDIATELY AFTER USE.

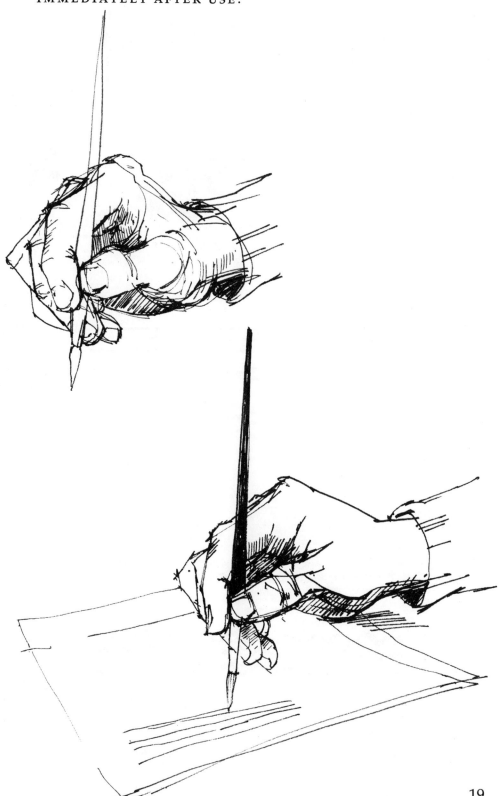

## Brush control exercises

Practise these freely drawn brush lines, and don't grip the brush too tightly.

The vertical and scribbly lines were made with the brush held upright and pointing directly down onto the paper. The broad short strokes running into one another were made with the brush held along the paper, almost horizontal.

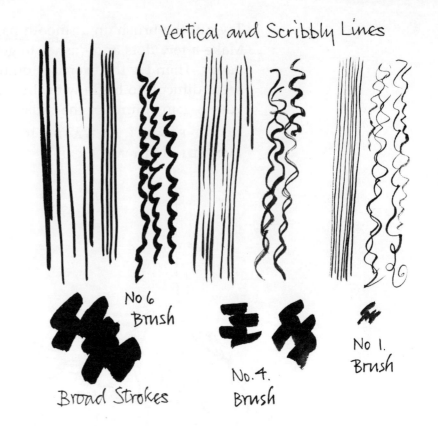

Vertical and Scribbly Lines

No 6 Brush

Broad Strokes

No. 4. Brush

No 1. Brush

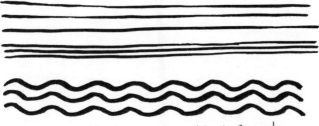

No. 6 Brush

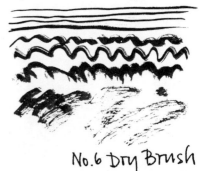

No. 6 Dry Brush

No. 1 Brush

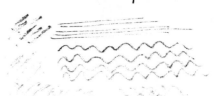

No 1. Dry Brush

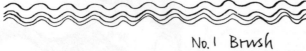

No. 6 and No. 1. Brushes

No 6 Dry Brush

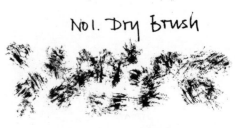

No. 6

20

Keep a piece of scrap paper beside you on which to test the brush before you apply it to your drawing. A brush full of ink will draw a dense line. A dry brush will produce a more varied texture or broken line.

**Brush-drawn patterns or letters**

Now try some freely drawn 'doodles', or experiment with your initials, using different sizes of brush. Here I have used a $\frac{5}{16}$" square brush and a No. 6 round brush. The cockerel was also drawn with a $\frac{5}{16}$" square brush, and some decorative pen work was added.

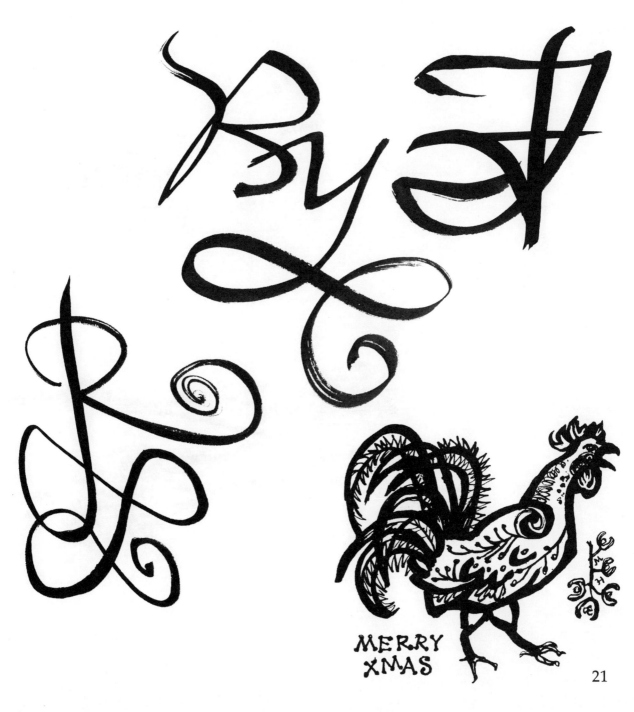

MERRY
XMAS

## Brush-drawn landscape

Stage 1—The landscape was lightly drawn with Indian ink and a dry brush. I used an old worn-down No. 6 brush and worked it on a scrap of paper until it was dry enough to produce the kind of line I wanted.

Stage 2—The darker trees and the hedges were added with the same stiff old No. 6 brush, this time with more ink on it. I started at the outer edges of the trees and worked the brush strokes in towards the centre of the growth.

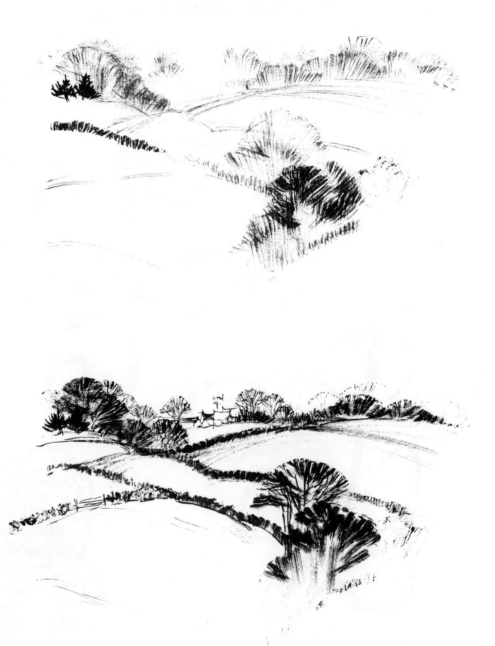

Stage 3—Finally the tree in the foreground and the details of the branches were added with a No. 3 brush and the church was drawn in with a No. 1 brush.

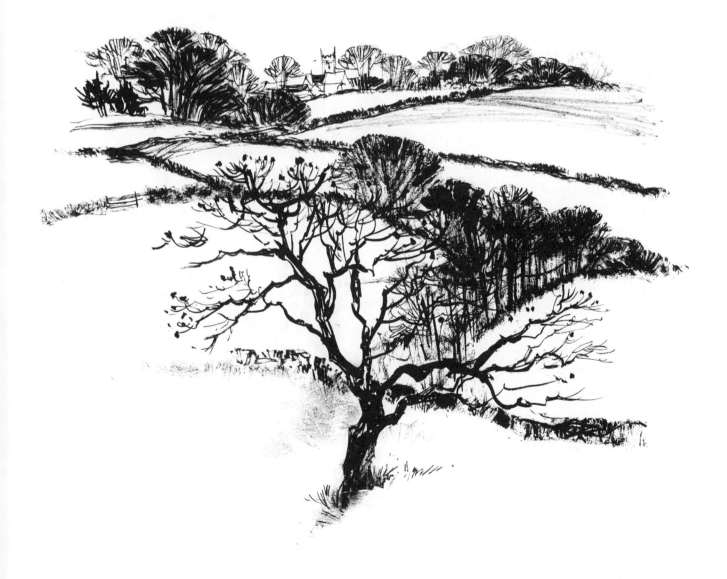

# Making marks with ink

The fine lines and dots at the top of the page were drawn with a pen and 303 nib. The nib is sensitive and by varying the pressure as you draw you can obtain thick or thin lines.

Variety can also be obtained by drawing with a stick dipped in ink. The point can be sharpened or left blunt. The wood quickly absorbs some of the ink, giving a dry quality to the drawing.

Blots of ink dropped onto the paper from an ink dipper can be blown in different directions with a straw or a fixative diffuser to produce angular, branch-like forms. The continuous tortuous line at the bottom of the page was made with the ink dipper itself.

Using a large brush (No. 10 or 12 sable or ox-hair), start a line with the tip of the brush and use pressure to broaden it, and then fine it down again to a point as you lift off the brush.

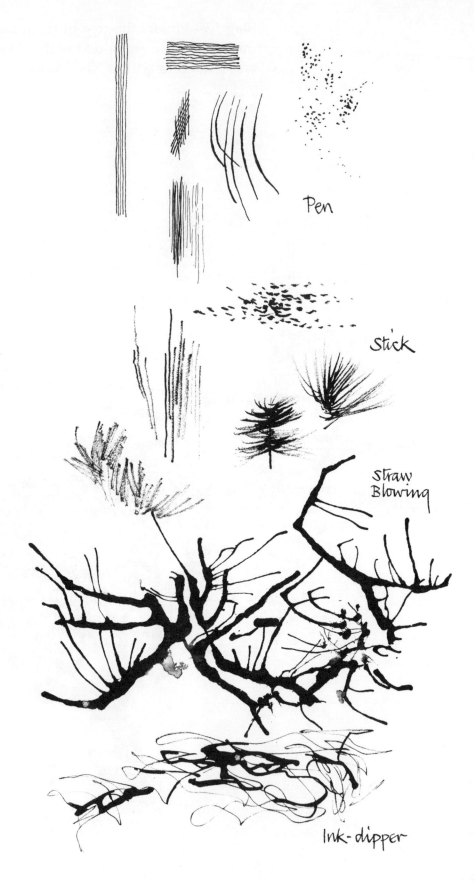

Pen

Stick

Straw Blowing

Ink-dipper

24

Use this technique to paint each side of a simple leaf shape with one brush stroke, leaving the white paper in the middle as a vein. Practise several, and try curved lines using different pressures.

Some of these leaves were painted with diluted Indian ink and some in solid ink.

The drawing on grey paper on page 26 was started with a $\frac{5}{16}''$ square brush and white ink. I then changed to black ink and used some of the methods of making marks described opposite.

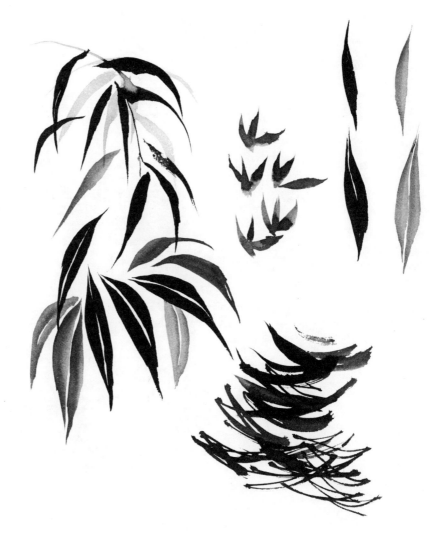

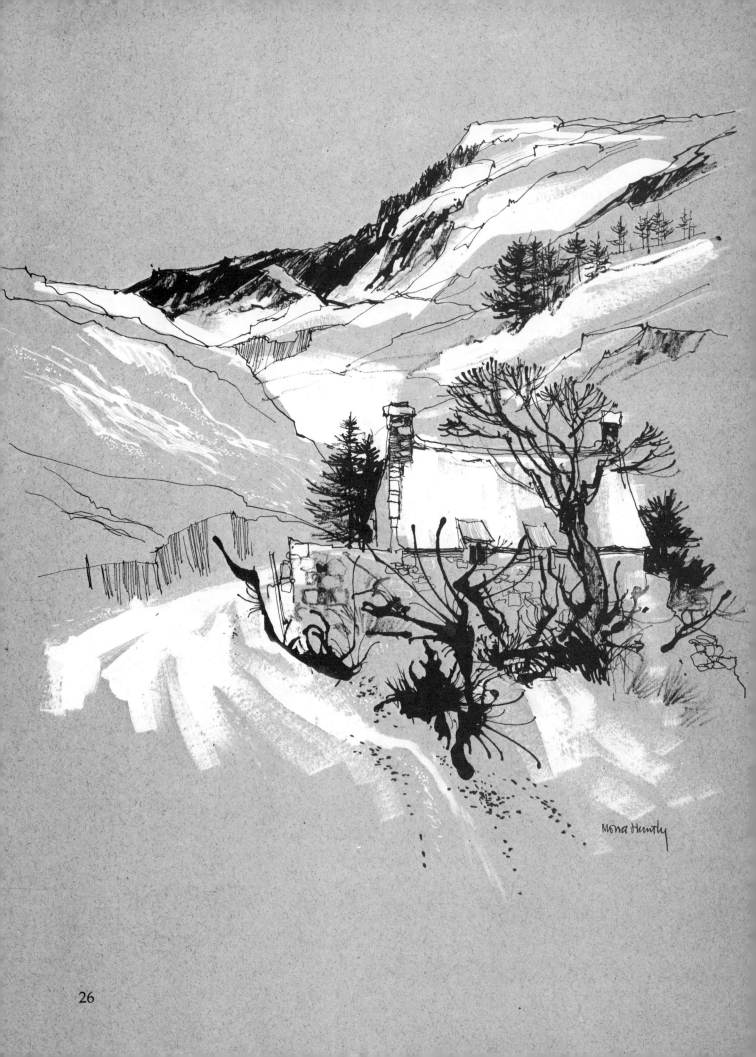

26

# Trees

## Ink and wash

1   Establish the shape of the tree first by drawing a light pencil outline, so that you can then concentrate on the brushwork.

2   For this tree, I used a No. 6 sable and diluted ink and dragged the brush across the paper.

3   I then drew into the wash with undiluted Indian ink, using a pen and smaller brush.

4   Here the tree outlines were drawn with pen and ink. Dilute ink washes were added with a square brush, sometimes worked across the trunks.

5   Solid ink was used to paint these trees, with a hog hair brush; the grasses were added as the brush dried.

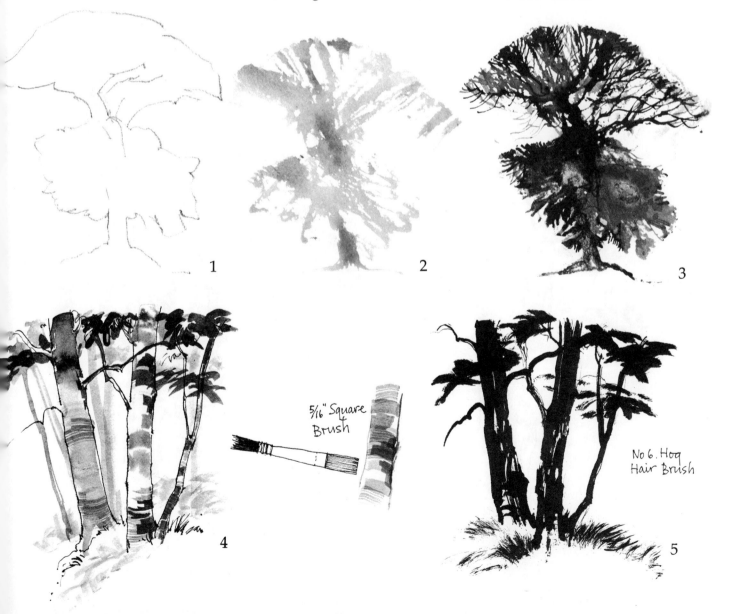

1

2

3

5/16" Square Brush

No 6. Hog Hair Brush

4

5

## Stick and ink

Again, you can establish the simple shape of the tree with a light pencil outline, and then start drawing with the stick. You will find that the stick makes a thick, solid line when first dipped into the ink, so start with the dark areas. As the stick dries, draw the lighter lines at the outer edges of the tree and the texture on the tree trunks.

Further detail can then be added with a pen.

The drawings here were also made with a pen and a stick, the stick being used mainly for the trees, as the details show.

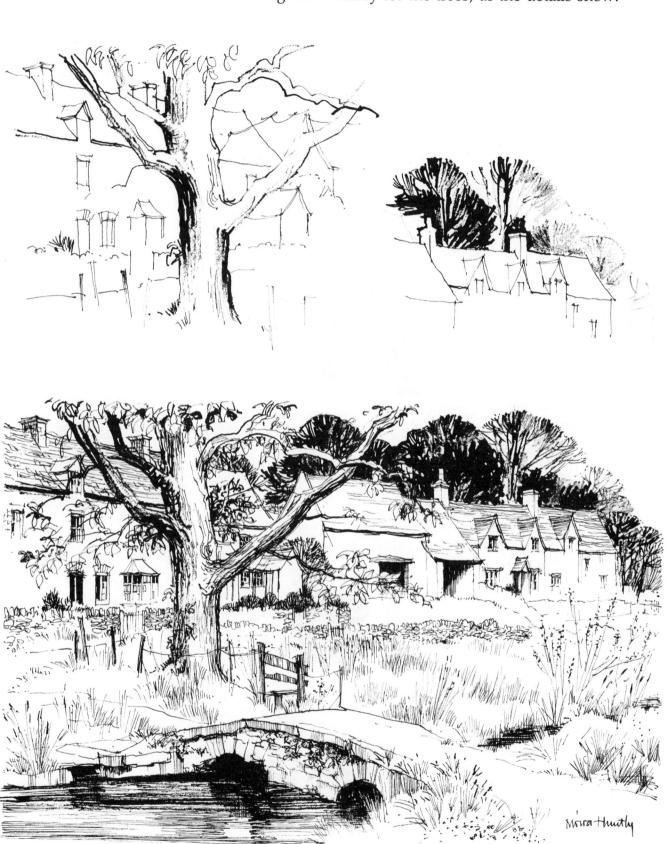

# Working wet into wet

Wet an area of rough watercolour paper with clean water, keep the surface flat, and drop Indian ink onto it from a brush. This makes very dark blots; but you will find that some of the ink will also spread to the edges of the dampened patch of paper with a pleasing pale grey mottled effect (figs 1 and 2).

Add some Indian ink to a small jar containing $\frac{1}{4}''$ of water and leave it overnight. Then dip a brush into the mixture of water and ink and drop blots onto dry watercolour paper. As the blots dry the ink separates out from the water to give a speckled effect within the blots (fig. 3).

Mixed ink and water dropped onto damp watercolour paper (fig. 4) will spread further but the central blots will again separate and produce a speckled effect.

Brush strokes can also be made with the ink and water mixture (fig. 5).

3

4

1

2

5

Have fun with some ink-blot doodles. I started this one with diluted ink blots, then added undiluted ink blots, on wet watercolour paper. I then decided to adapt the blots into imaginative plant forms.

I drew into the wet paper with a pen to obtain the fuzzy stems, and the more precise lines were added as the paper dried.

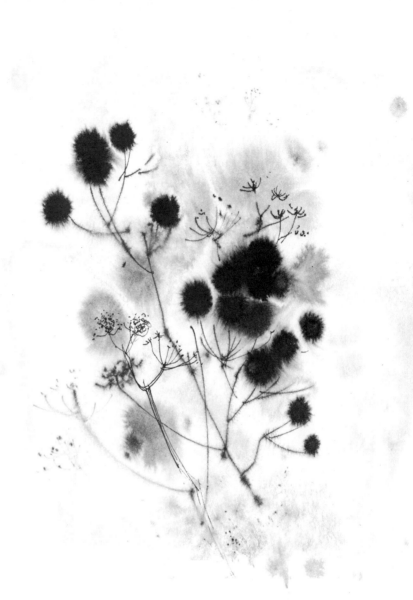

# Tone with ink washes

Stage 1—I put a wash of clean water over a piece of flat watercolour paper, and painted some brush strokes of very dilute ink into the damp paper, leaving some of the paper showing. I dabbed off extra light areas with a paper tissue. This process gave the softly patterned surface shown here on the left.

Stage 2—The darker tones were added while the first wash was still damp, using a less dilute mixture. I painted between the tree trunks at the top, leaving the trunks themselves as the original light wash, and dabbed off the soft foliage with a tissue. Some pure ink was dropped in here and there with a small brush.

Stage 1

Stage 2

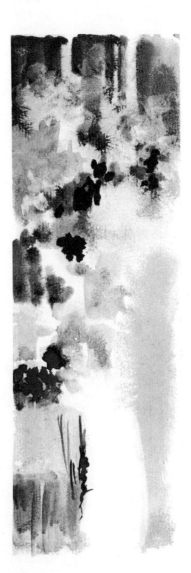

Final stage (below left)—I added some drawing with a pen and stick and diluted ink. Further detail was added with a pen and undiluted ink. When the painting was quite dry I drew some plant detail with a pen and white ink.

The other tone painting, on the right, was made in the same way. When the paper was nearly dry I dragged a large brush across the foreground to give a broken effect.

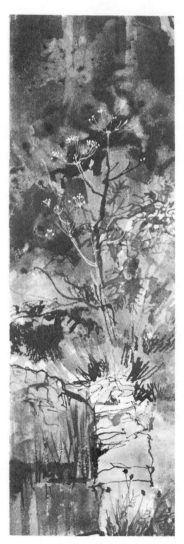

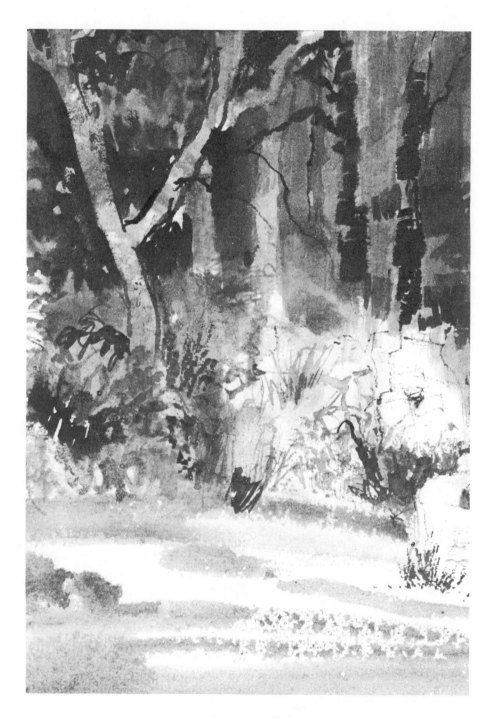

# Pen and wash

Stage 1—These farm buildings were drawn in with a simple pencil outline on watercolour paper. Clean water was washed over the tree area with a large brush. I then used dilute ink and a $\frac{5}{16}$″ square brush to lay in the first light washes on trees and buildings.

Stage 2—I darkened the ink mixture and painted in the roofs, using the full width of the square brush and making the brush-stroke follow the slope of the roof. The suggestion of tree branches was added with a No. 2 or No. 3 brush.

Final stage—Further dark ink washes were added to the muddy track in the foreground. Finally, the pencil lines were rubbed

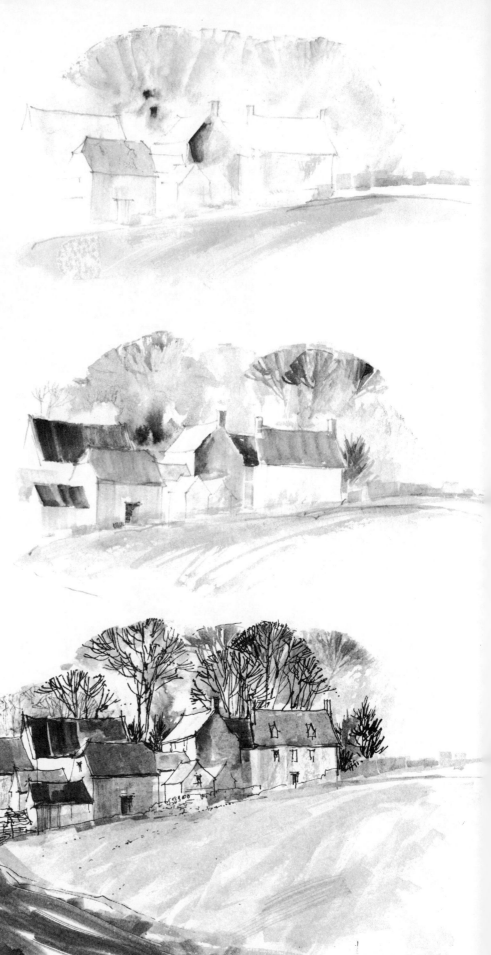

off and I drew freely with pen and ink over the wash, not worrying about whether the pen line coincided exactly with the edge of the wash. This apparently careless attitude gives life to a pen and wash drawing.

This drawing of the seashore includes many of the techniques used in the book so far: dilute ink washes, stick and ink, pen and ink, dry brush work, and ink dropped onto a wet area. Colour washes and transparent watercolour can also be added when the ink is dry.

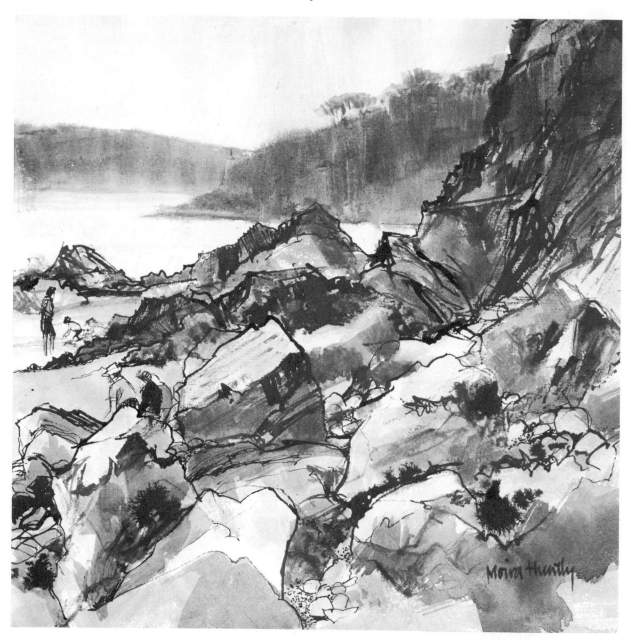

# Tone with line

This holiday sketch was made with a felt-tip pen. I started with a simple outline, then built up the tones to create depth, increasing the number of lines and sometimes the thickness of the line for the darker shadows until they became almost a solid dark inside the cave. By varying the angle of the line work I was able to indicate the different planes of the rock surface.

The drawing of the headland, opposite, was made with a fine fibre-tip pen and a thicker felt-tip pen. I used the finer point for the background rocks and foreground details, and the thick felt pen for the nearer rocks and dark shadows. Recession is created by this use of thick and thin lines—the darker, thick lines come forward, and the thin line on the horizon seems far away by comparison.

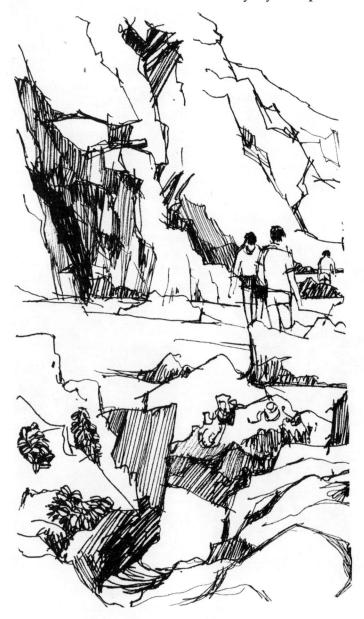

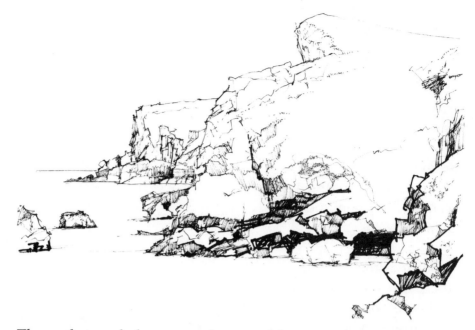

The archway, below, was drawn with a pen and Indian ink. Again, the main shading is made up of a series of lines which follow the direction of the surfaces, with additional cross-hatching in some areas.

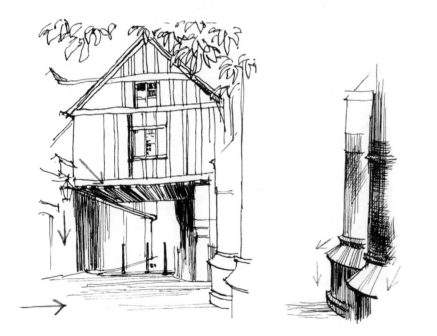

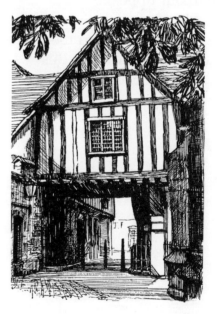

These drawings from my
sketch books show more
use of line and tone. The
ships on the right were
drawn with a blue ball
point, and will be used as
the basis for a larger
painting. The boat on the
beach, below, was drawn
directly with a pen and
Indian ink.

The boats at the bottom
of the page opposite were
also drawn with Indian
ink, so it was possible to
add a colour wash to this
afterwards.

The drawing of the
harbour opposite was
made with a felt-tip pen,
which is not waterproof;
so adding a wash to this
would probably ruin it.

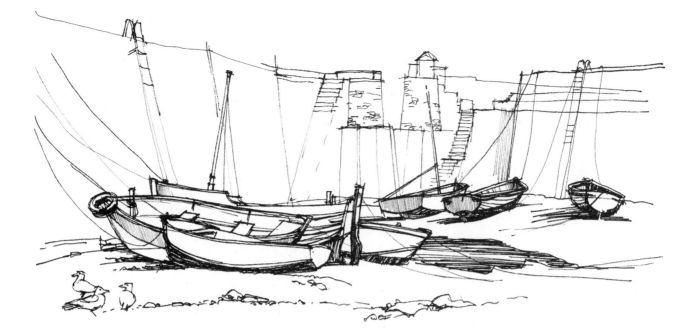

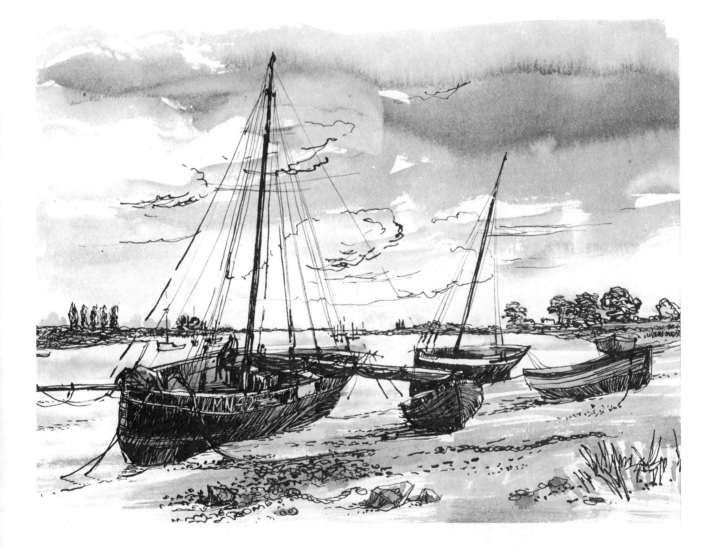

39

# Where to draw

Carry a small sketchbook in your pocket whenever you can; there will be many occasions when you can use it.

When travelling, for instance, it is useful to be able to while away an irritating wait for a train or plane by making quick notes and exploratory sketches. I made these railway station sketches with a fountain pen. The holiday sketch of the coastline from the beach was made with a blue ball point.

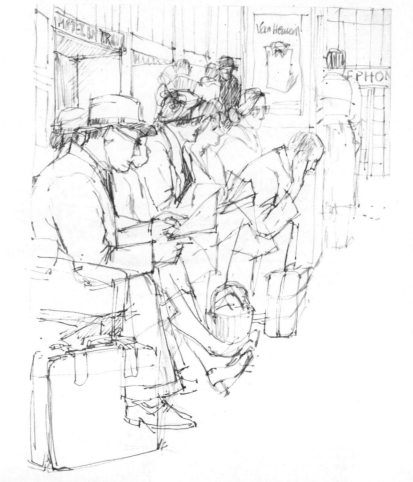

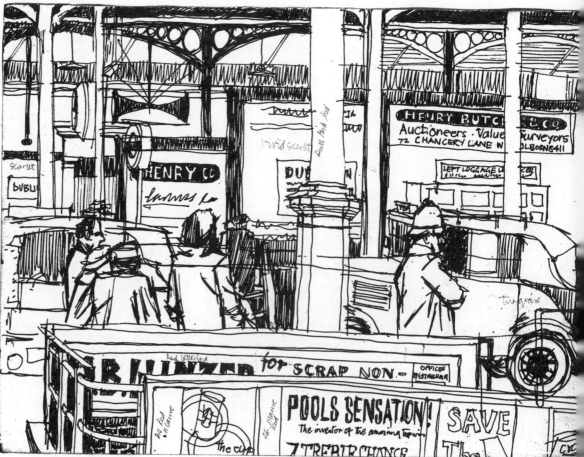

40

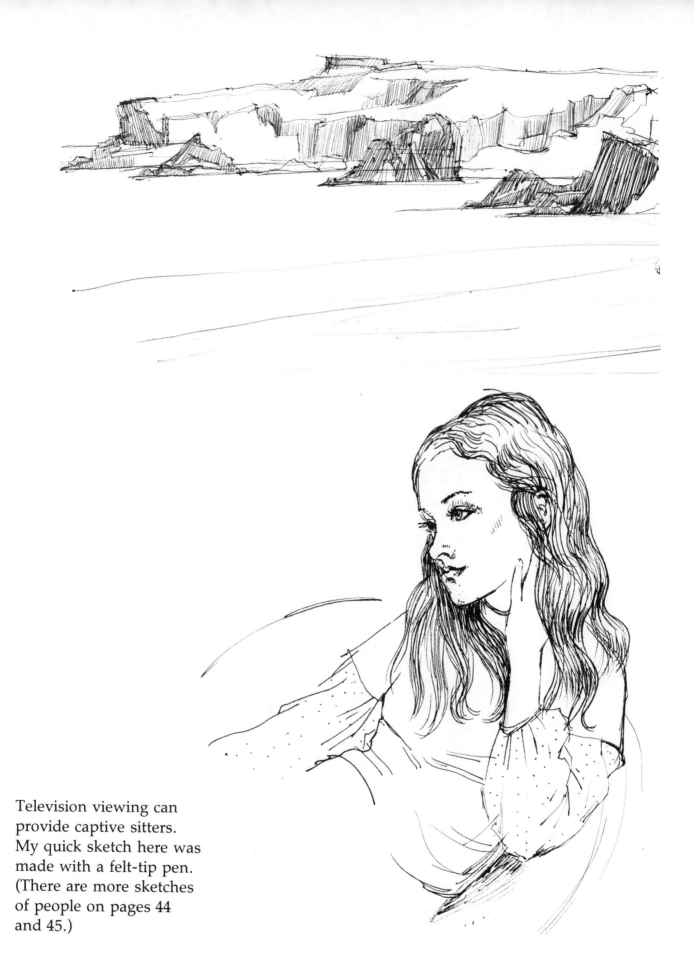

Television viewing can
provide captive sitters.
My quick sketch here was
made with a felt-tip pen.
(There are more sketches
of people on pages 44
and 45.)

I had to stand between two cars in order to make this quick sketch, with a felt-tip pen, of the jumble of roofs behind Covent Garden, London. Fibre and felt-tip pens are very useful for this kind of on-the-spot drawing, especially in a situation where you cannot find anywhere to stand a bottle of ink. Don't forget, though, that they are not waterproof and are not a permanent medium.

This sketch provided helpful inspiration when I wanted to use buildings in a design.

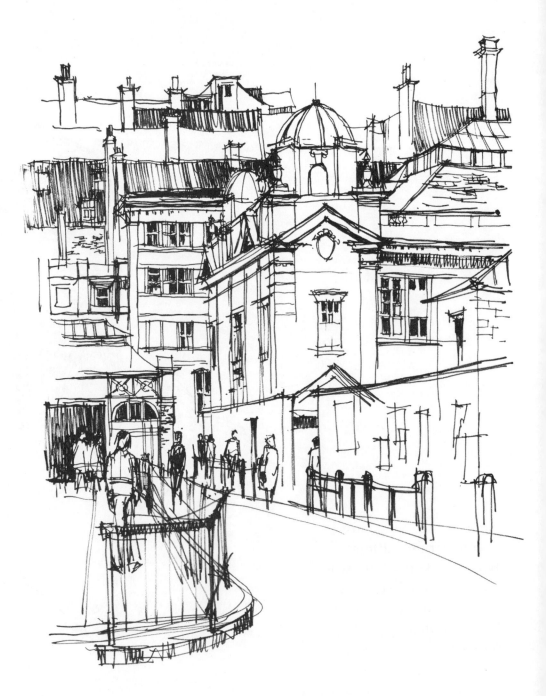

This drawing, also done with a felt-tip pen, combines the fascination of boats and harbour scenes with the varied shapes and patterns of buildings and stonework. Before you embark on a large drawing with this type of pen, make sure you have a spare one with you in case the ink runs out.

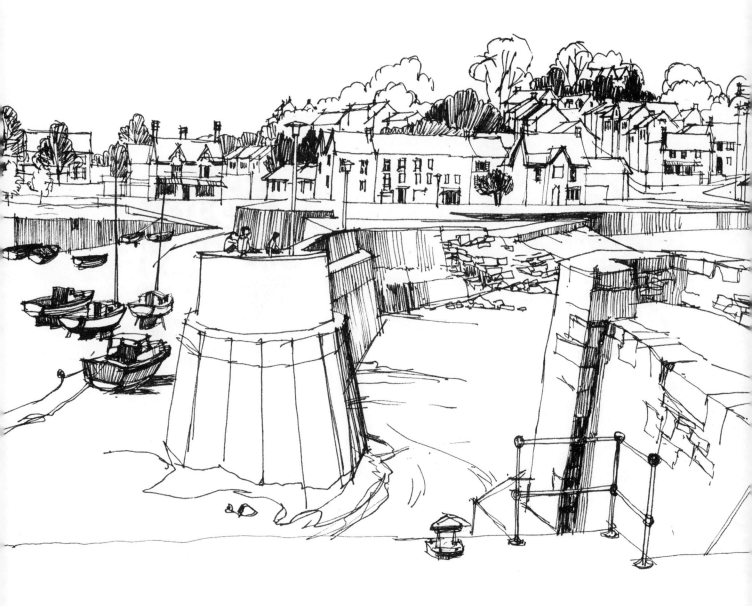

# Sketching people

You may be able to persuade your family or friends to sit for you, or catch them unawares while reading or watching television. Sometimes it is possible to make quick sketches of people in the park, railway station or café if you can find a good vantage point. Again, fountain pens and felt-tips are useful.

This sketch of a girl was drawn directly with dilute ink and a No. 4 sable brush, but you can draw a light pencil outline first if you prefer. The darks of the hair and eyes and the details of the face were added with undiluted ink, using the same brush.

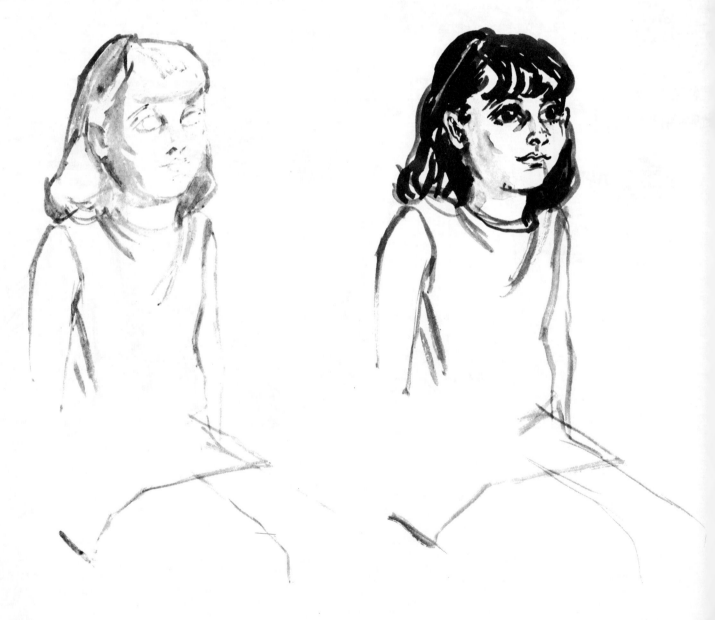

Indian ink and a brush were also used for the man's head, and I used a fountain pen filled with blue-black ink for the drawing of the child writing at a desk.

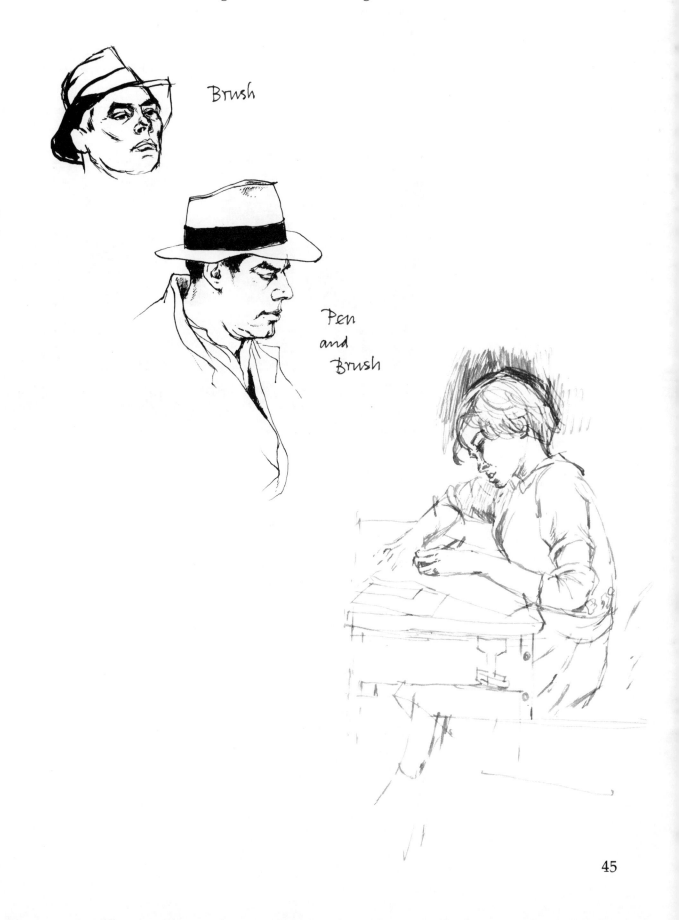

Brush

Pen and Brush

# Designs in ink

The abstract design based on squares and circles was painted on watercolour paper with a yellow-green ink and a No. 6 brush. Olive green and burnt sienna inks were added to some areas, and in places painted over the first colour. Coloured inks are transparent, so by painting one colour over another when the first one is dry you can create a third colour. When all the ink was dry, candle wax was rubbed over parts of the design. I then added dark inks over this wax, allowed it to dry, and scraped through it with a razor blade to expose some of the colour underneath.

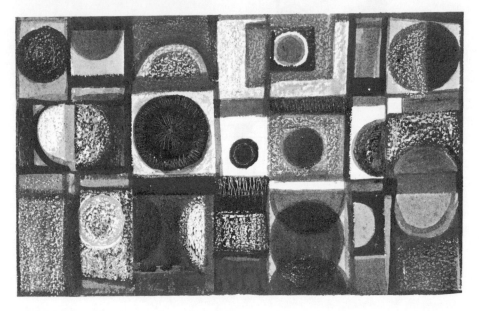

In the fish design, four different coloured inks were dropped onto wet paper (see pager 30). The small circles were made with the end of a straw dipped into the ink. Remember that coloured inks are not permanent and may fade over the years.

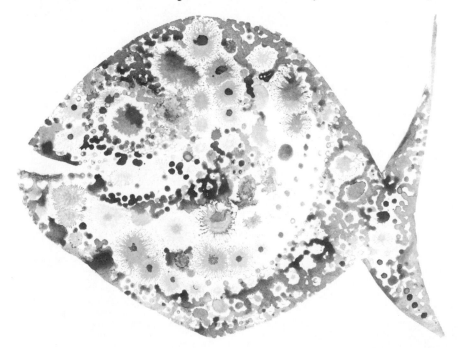

These musical instruments were drawn freely with a
pen and white ink on a piece of dark brown card.

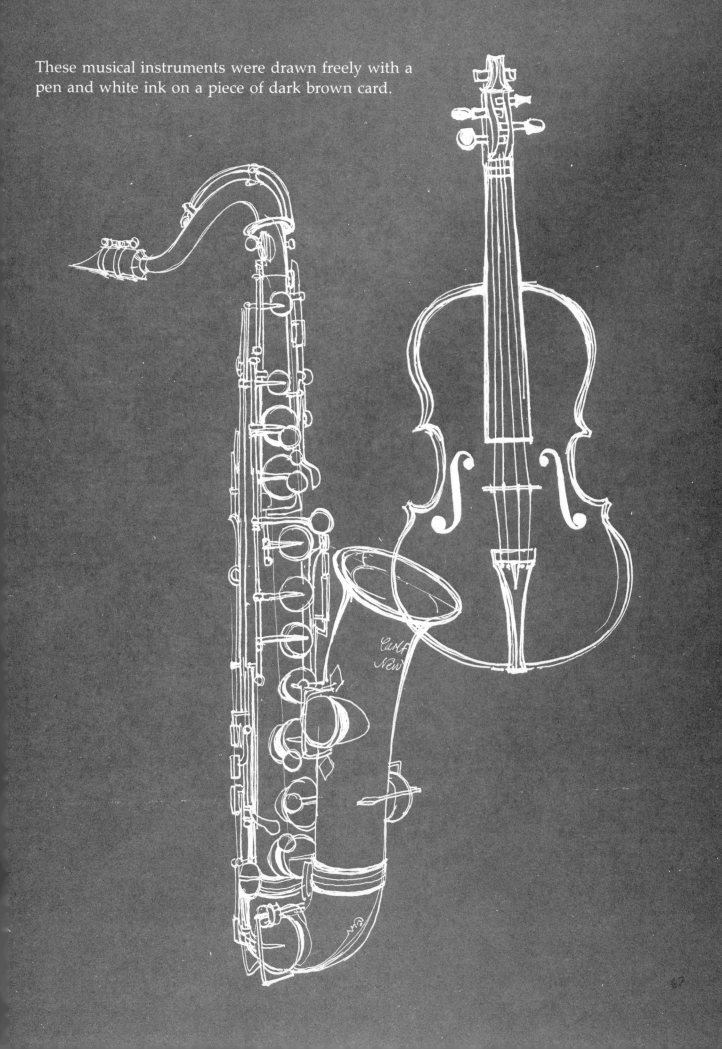

# Drawing for reproduction

I used Indian ink with a brush and pen for the design on the right which was reproduced in colour as a greetings card.

If I am making line drawings or designs for reproduction I always use Indian ink and I often make the original drawing larger by half than the finished printed drawing will be.